AGNES PELTON

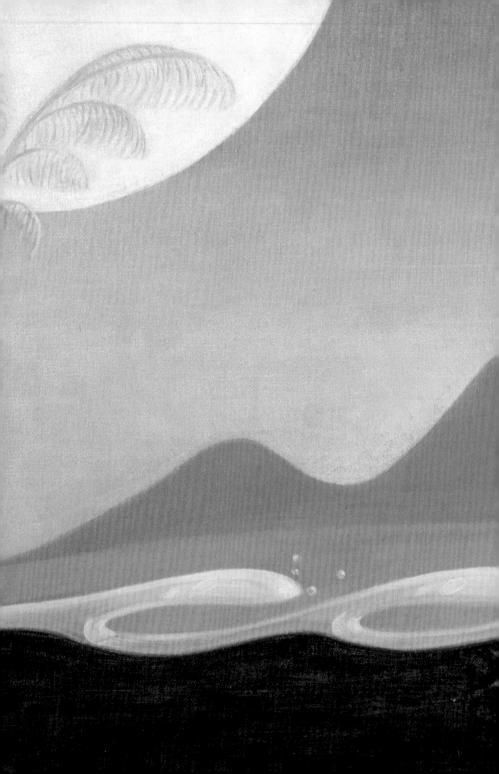

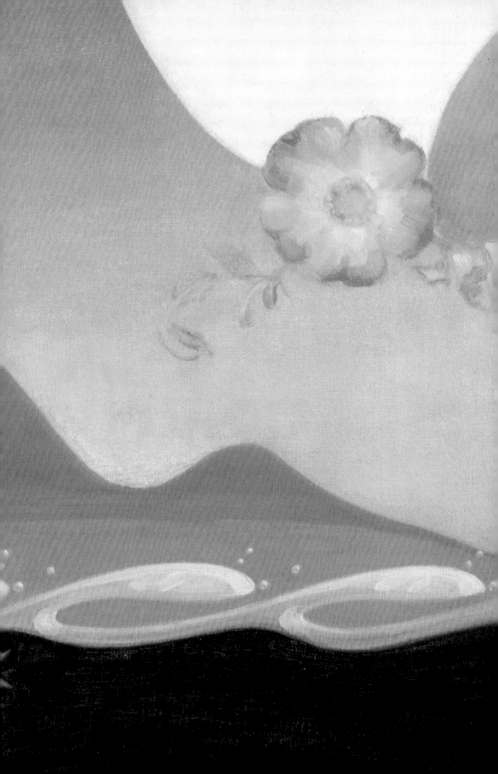

AGNES
PELTON

Gilbert Vicario

HIRMER

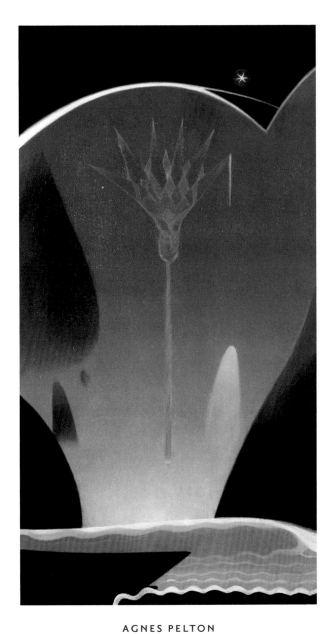

AGNES PELTON
Lotus for Lida (Egyptian Dawn), 1930, oil on canvas
36 × 18 in., Collection of Lynda and Stewart Resnick

CONTENTS

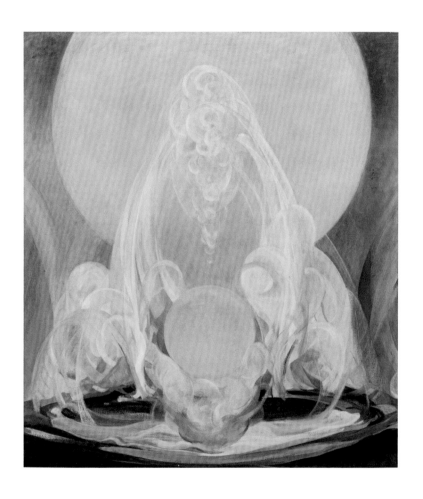

1 *The Fountains*, 1926, oil on canvas, 36 × 31½ in.
Collection of Georgia and Michael de Havenon

AGNES PELTON

Gilbert Vicario

Almost a century has passed since Agnes Pelton (1881–1961) began exploring abstraction and spirituality in her paintings. We are still laying the groundwork for a greater understanding of this artist's contribution to American Modernism. Her distinctive paintings can be described as metaphysical landscapes rooted in the California desert near Cathedral City, a place she called home for almost 30 years, and yet they grew out of a sensibility firmly established prior to her arrival in the West. Born to American parents in Stuttgart, Germany, Pelton and her family briefly lived in Basel, Switzerland, before returning to the United States in 1888. She graduated from the Pratt Institute in Brooklyn in 1900, and that same year worked as an assistant teacher at the Ipswich Summer School of Art in Massachusetts. Both programs were shaped by the highly influential arts educator Arthur Wesley Dow, whose students included Georgia O'Keeffe and Charles Sheeler. In 1910, Pelton spent a year studying life drawing at the British Academy of Arts in Rome, and she exhibited in the Armory Show of 1913 at the invitation of the painter and art promoter Walt Kuhn. Her first encounter with the Southwest came at the instigation of Mabel Dodge Sterne, who invited Pelton to her home in Taos in 1919. From 1921 to 1926, she traveled extensively to far-flung places including lengthy stays in Hawaii and Syria, which afforded her firsthand knowledge of the

seemingly contradictory landscapes and flora of these two diverse locales. During the 1920s, she matured into an artist whose interpretations of earth and light, biomorphic compositions of delicate veils, shimmering stars, and atmospheric horizon lines, distinguished her abstract work and sparked her artistic passion. Intentionally moving away from the East Coast arts community for practical and financial reasons, Pelton eventually settled in Cathedral City, California, in 1932.[1]

Early on, newspaper journalists in California sometimes compared her to Georgia O'Keeffe, who was six years her junior. Both artists studied with the same teachers, and both read Wassily Kandinsky's essay *Concerning the Spiritual in Art*, as did many artists of the time.[2] But the underlying subtext here is that they were both women and since there were so few artists and specifically women artists to make credible comparisons with what Pelton was exploring in her abstract works, O'Keeffe's name always rose to the top.[3] To be fair, their education, shared interests, and their relative geographic proximity makes a comparison between the two understandable, yet at the same time put paid to any attempt to give the less visible of the two artists her proper due. Unlike Pelton, O'Keeffe approached the world

in a direct way and tended to focus on natural elements such as flowers and land formations. While there were varying degrees of abstraction in her work, there was very little in the way of imaginative or philosophical connections like those that underpinned Pelton's compositions. In fact, part of O'Keeffe's brilliance lay in the way she stayed within the margins of reality by anchoring the works with descriptive titles such as *The Apple, White Rose*, and *Pink Abstraction*, whereas Pelton often struggled to find the perfect corresponding title for her abstractions. O'Keeffe also had an advantage over Pelton in being able to count on a powerful advocate and partner in Alfred Stieglitz, who was instrumental in championing her work while providing critical feedback. Pelton, like most women artists, had none of this, which made it difficult for the mainstream art world to accept her unique style of abstraction in a male-dominated art world, largely disconnected from the East Coast, and without the benefit of individuals supporting her work. Pelton was no eccentric who lived in seclusion, but rather lived quietly with a small circle of friends and acquaintances in a community that allowed her to focus on her work. Her passion was her abstractions, but she also painted realistic desert scenes, smoke trees, Joshua trees, and the San Jacinto Mountains, which inspired her

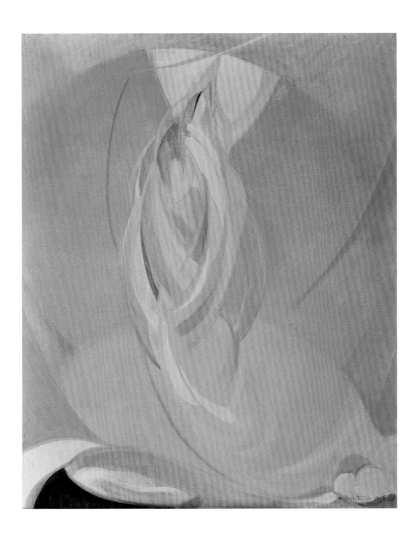

2 *Meadowlark's Song*, Winter, 1926, oil on canvas, 25 × 20 in.
Collection of Maurine St. Gaudens

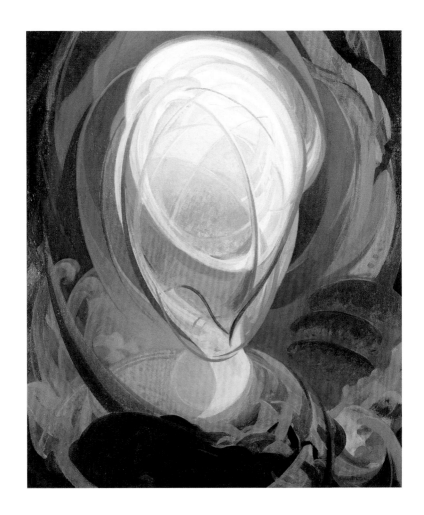

3 *Being*, 1926, oil on canvas, 26 × 21⅞ in.
Private Collection, courtesy Alexandre Gallery, New York

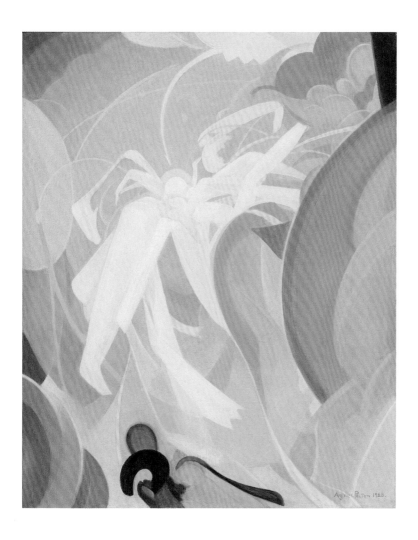

4 *Ecstasy*, 1928, oil on canvas, 24 × 19 in.
Des Moines Art Center's Louise Noun Collection
of Art by Women through Bequest

5 *Caves of the Mind*, 1929 Oil on canvas 25½ × 26½ in.,
Euphrat Museum of Art, Cupertino

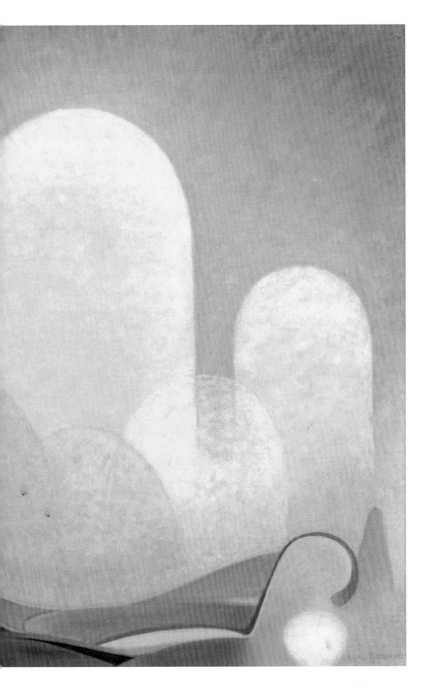

throughout her time in the desert. Pelton sold these landscapes alongside her abstractions; they helped pay the bills, but also gave her a creative outlet that was very different from her abstract compositions.

Her abstract body of work emerged in the 1920s, out of a nascent period that was marked by the production of what she called her *Imaginative* paintings. These Arcadian compositions, brushy and with a darkened palette, consisted of female figures placed in natural settings such as wooded forests, grottoes, or windswept landscapes. *Room Decoration in Purple and Gray* is a transitional painting between her Imaginative paintings and her mature abstract paintings from the 1920s. It features a figure that grounds a fantastic landscape of overlapping veils of color with a floral arrangement and a small glimpse of a hillside in the background. Unlike the earlier paintings, this piece demonstrates the influence of the American modernist Arthur Beecher Carles, her instructor, whose own work was deeply informed by the works of Paul Cézanne and Henri Matisse. A significant formal and conceptual break from these early compositions is achieved in *The Ray Serene*, which does away with the figure and ground entirely and instead creates a work of pure abstraction. Inspired by German Expressionist formal techniques and perhaps Pelton's subjective iteration of synesthesia, with which Wassily Kandinsky was so closely associated, its composition is dominated by organic shapes and lines, and saw-toothed brush marks that define and contrast areas of surface and depth. Paintings such as *The Fountains* (1) and *Being* (3), which followed after *The Ray Serene*, become completely untethered from reality and move towards a surreal embodiment of light, space, and vibrations that borders on science fiction. By the 1930s, earth-bound elements return to her paintings. Horizon lines, twinkling stars, and landforms reorient Pelton's abstractions into *sui generis* compositions that are drawn chiefly from her own inspirations, superstitions, and beliefs to exemplify emotional states. These in turn are made manifest in ethereal veils of light, jagged rock forms, and exaggerated horizons that become like theatrical stage sets, both symbolizing and exemplifying an idealism that one can argue is rooted in the philosophical tenets of nineteenth-century American transcendentalism.

Much of Pelton's work is inspired by her interest in Agni Yoga and its principal focus on fire as a guiding force. Because of this and other esoteric interests she was asked to participate in an incipient collective of artists known as the Transcendental Painting Group (TPG) (1938–1941) that

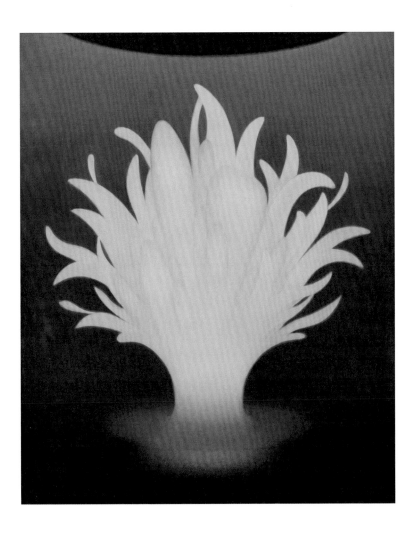

6 *The Voice*, 1930, oil on canvas, 26 × 21 in., University of New Mexico Art Museum
Bequest of Raymond Jonson, Raymond Jonson Collection

promoted like-minded artists. This short-lived group was formed by the artist Raymond Jonson, who was dissatisfied with the term "non-objective", and it included Emil Bisttram, Ed Garman, Robert Gribbroek, Lawren Harris, William Lumpkins, Florence Miller Pierce, Horace Towner Pierce, and Stuart Walker.[4] Based in Santa Fe, New Mexico it was Jonson, in fact, who convinced Pelton to join the group. In a letter dated June 4, 1938, Jonson asks Pelton, "…I should like to know what you think of using the word transcendental to designate it [Pelton's paintings], instead of abstract or non-objective. Does this word seem to you to cover the aim of our work insofar as the objective departure and the hope for spiritual content are concerned?"[5] The TPG reconnected Pelton to the Southwest, albeit briefly, but there is no evidence that she ever traveled back there for any reason. The extent of her involvement with this group, aside from being named honorary president, seemed to be her participation in a few exhibitions during its short-lived run. After 1941, and the demise of the TPG, Pelton, now 60 years old, slowed down on the production of her abstractions and temporarily turned her attention to the desert landscapes that brought in some much-needed income.

By the 1950s Pelton's output was reduced due to failing health, and she died from liver cancer on March 16, 1961. Leaving no immediate heirs, the remains of her belongings were distributed to her cousins. In a letter written after Agnes' death to her cousin Laura Gardin Fraser on July 28, 1961, Pelton's friend and caretaker Gerry Goodall recounts, "I get sick every time I think of the abstraction Agnes gave to the Santa Barbara Gallery— worth many hundred dollars, and because the curator didn't understand or like abstractions, it was put in the White Elephant Sale for $40.00. Alice Kennedy saw it, and while she was out cashing a check to buy it—the price had been reduced to $15.00."[6] One can imagine that there were other oversights after her death that led to the misplacement of works; however, Pelton's slow reemergence within the margins of American art began through critical and academic reevaluations of her place in art history. In the 1980s, archival efforts aimed at establishing a baseline of primary

7 *Rose and Palm*, 1931, oil on canvas, 37 × 23 in.
Euphrat Museum of Art, Cupertino

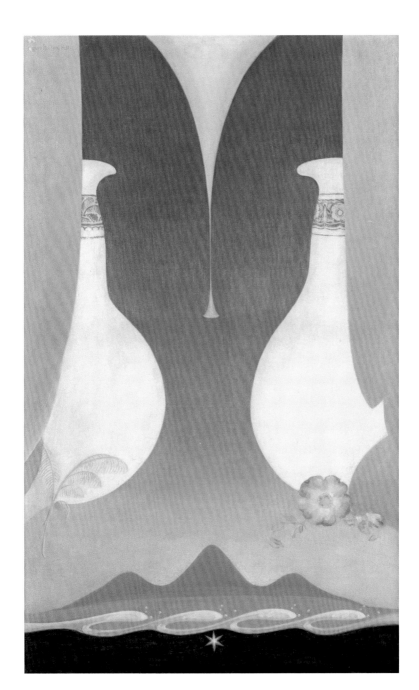

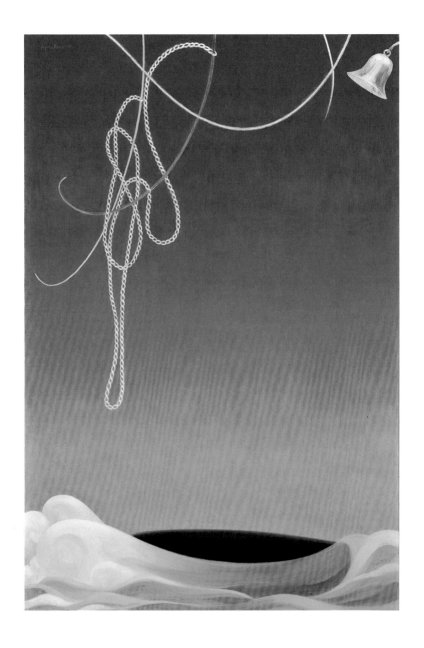

8 *Voyaging*, 1931, oil on canvas, 36 × 22 in., Jeri L. Wolfson Collection

research materials began to take shape. The Agnes Pelton Papers at the Smithsonian Institution were assembled by Cornelia and Irving Sussman for a biography. They were donated to the Archives in 1984 by gallery director Jan Rindfleisch on behalf of the Sussmans. In 1997, around 162 letters from Agnes Pelton to Jane Levington Comfort, that are now part of this collection, were bequeathed to Cornelia and Irving Sussman by Jane Levington Comfort through Joan Crisci, the executor of Comfort's estate, and donated to the Archives.[7] The majority of Pelton's works were catalogued in a publication for an exhibition curated by the art historian Margaret Stainer in 1989, her first solo exhibition since 1955.[8] In fact, this publication demonstrates that she might have realized just under one hundred of her abstractions.

Many of Pelton's abstractions were acquired, in some cases during her lifetime, by California museums including the San Diego Museum of Art, The M. H. de Young Memorial Museum, Oakland Museum of California, and the Huntington Library and Gardens in Pasadena, along with Southwest museums such as the Museum of the University of New Mexico in Albuquerque and the New Mexico Museum of Art in Santa Fe. In the last twenty years a handful have made their way to the Midwest and the East Coast, Des Moines, Miami, New York, and Boston. This migration has steadily increased in recent years. The Des Moines painting *Ecstasy* (4), was acquired in 1988 by Louise M. Noun, an important and forward-thinking collector of women artists, while the Whitney Museum of American Art in New York City acquired an untitled work from 1931 in the late 1990s, and then *Sea Change* a few years later, while Phoenix Art Museum's two paintings, thought to have been lost, only entered the collection in 2014.

In recent years, there has been a resurgence of interest in Agnes Pelton, in part as a result of a continued appreciation of and fascination with the American art of the West and Southwest and Pelton's points of intersection with other artists in the region, in addition to a new generation of artists and art historians seeking to expand the discussion around abstraction and spirituality. Despite Agnes Pelton's small but devoted following among curators, art historians, and artists, she has remained relatively unknown and largely misunderstood within the canon of American Modernism. The landmark exhibition *The Spiritual in Art: Abstract Painting 1890–1985*,[9] for example, included just one painting by Agnes Pelton, whereas other artists of the same period fared much better. Pelton's first survey exhibition,

9 *Translation*, 1931
Oil on canvas
25 × 30 in.
Fairfax Dorn and
Marc Glimcher

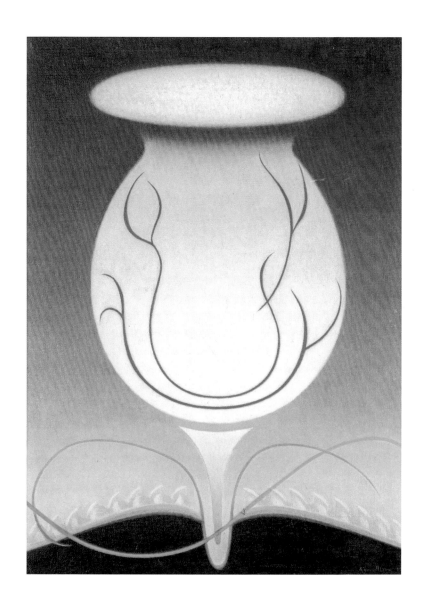

10 *Chalice*, 1932, oil on canvas, 30 × 18¾ in.
Euphrat Museum of Art, Cupertino

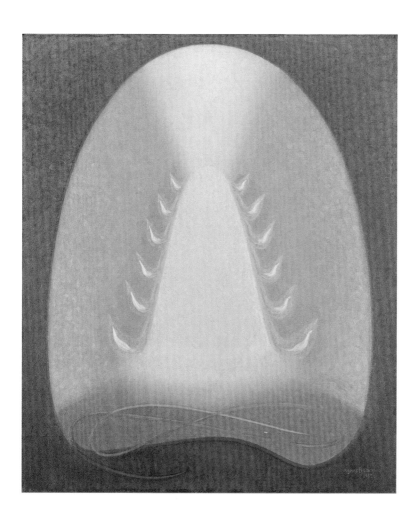

11 *Mount of Flame*, 1932, oil on canvas, 24 × 20 in., University of New Mexico
Art Museum, Bequest of Raymond Jonson, Raymond Jonson Collection

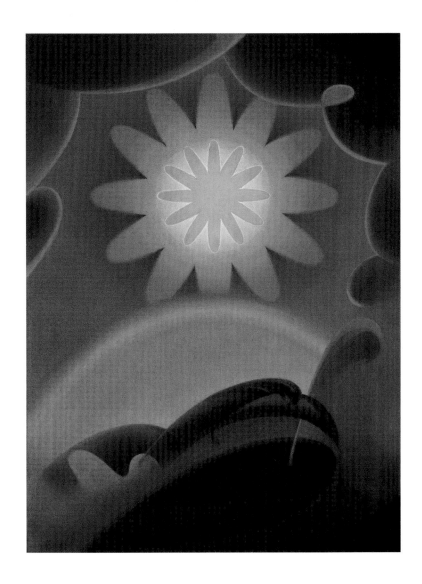

12 *Sand Storm*, 1932, oil on canvas, 30¼ × 22 in.
Crystal Bridges Museum of American Art, Bentonville

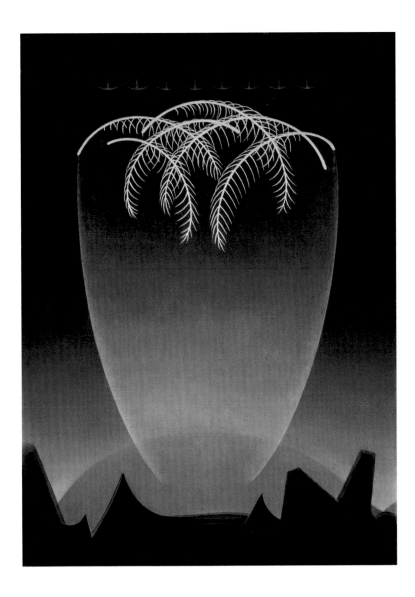

13 *Messengers*, 1932, oil on canvas, 28 × 20 in., Phoenix Art Museum

Agnes Pelton: Poet of Nature (1995), traveled extensively throughout the United States, yet a 1995 review in the *New York Times*[10] characterized her work as uneven and erratic, and incorrectly implied that it was she who was inspired by the Transcendental Painting Group and not the other way around. Other reviews of the time were more in tune with her particular form of abstraction, while noting that her work received less attention than the Surrealist-driven and Jungian-driven abstraction of the time.[11]

Nowadays, Pelton's greatest advocates seem to be a new generation of mostly contemporary women painters, who perhaps are the true receivers of the messages Pelton sent many years ago. Many contemporary painters that resonate with or know of her abstractions include the artists Mary Corse, Matthew F. Fisher, Loie Hollowell, Carrie Moyer, Alex Olsen, Linda Stark, and Mary Weatherford. For contemporary artists, Pelton's work represents a unique sensibility formed both inside and outside of a neat chronological framework separating abstraction from representation. It in fact embraces both genres in varying degrees, in order to disrupt the painterly logic of surface and illusion, and conversely abstraction's rejection of artifice and visual representation. In other cases it is simply the use of light as a medium that bridges Pelton's early explorations with contemporary artists. It is through these formal reverberations that we begin to see an artistic interplay that connects across multiple decades. Weatherford's interest in light as an artistic medium links directly with Pelton's interest in giving shape to light in space in works such as *The Blest* (23), and *Light Center* (25), whereas *Ruins* by the L.A.-based artist Linda Stark resonates strongly with metaphysical explorations of landscape in works such as *Sand Storm* (12) and *Messengers* (13). Aside from being inspired by Pelton's work, many of these artists have also actively participated on a curatorial level aimed at raising awareness and interest in Pelton's life and work. Weatherford, in fact, delivered a lecture on the artists at Ballroom Marfa in 2016, entitled "Agnes Pelton and the American Transcendental."[12] "The Ocular Bowl," a cross-generational exhibition in 2016 featuring the work of Alex Olsen, Linda Stark, and Agnes Pelton centered on both the physical and metaphysical manifestation of sight and its effects on mind and memory.[13]

In the fall of 2021, the Los Angeles-based artist Ariana Papademetropoulos organized a solo exhibition and curatorial project titled, *The Emerald Tablet*. The exhibition celebrated "the intersection of the occult and the

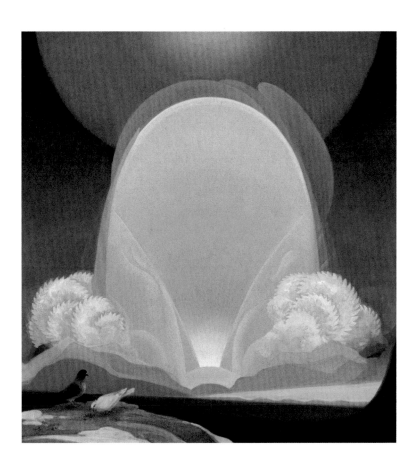

14 *Winter*, 1933, oil on canvas, 30 × 28 in., Crocker Art Museum

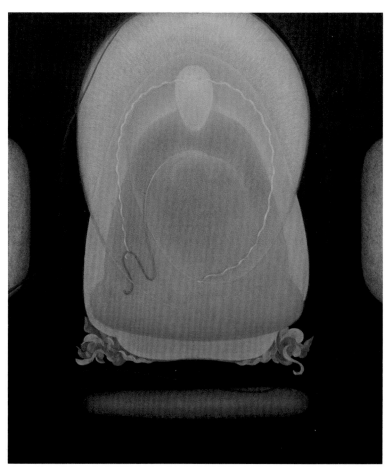

15 *Mother of Silence*, 1933, oil on canvas, 30 × 25 in., Private Collection

magic of set design, blurring the world of cinema and the great beyond."[14] The exhibition features a cross-generational selection of artists from contemporary artists living in Los Angeles to Modernist masters such as Leonora Carrington, Henry Darger, and Agnes Pelton. In homage to Agnes Pelton, Papademetropoulos installed the gallery as a reimagination of The Emerald City as a spiritualist landscape. Most surprising was the fact that

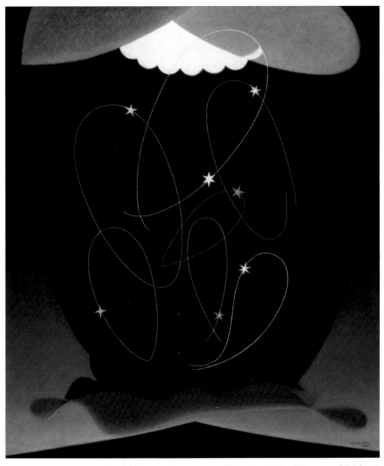

16 *Orbits*, 1934, oil on canvas, 36¼ × 30 in., Oakland Museum of California

all four Pelton paintings included in the exhibition have been rarely seen or were thought to be lost, including *Caves of Mind* (5), *Rose and Palm* (7), *The Chalice* (10), and *Face to Face* (26). Art historian Jan Rindfleisch writes that in *Caves of Mind*, Pelton's abstract painting is brimming with three light-filled arches. Luminous glowing shapes, rounded expansive forms create a visionary, spiritual background for darker and complex recumbent

34
35

17 *Day*, 1935, oil on canvas, 25¼ × 23½ in., Phoenix Art Museum

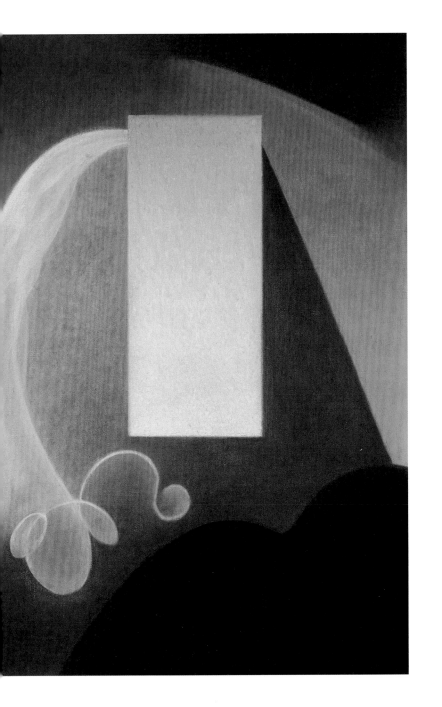

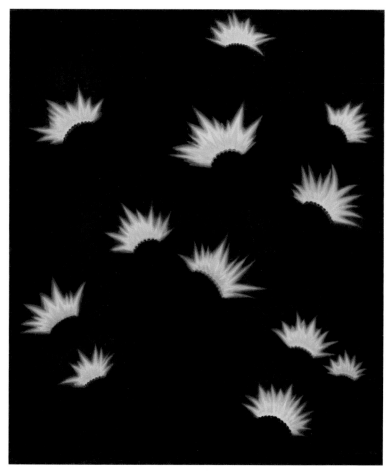

18 *Fires in Space*, 1938, oil on canvas, 30⅛ × 25 in.
Collection of halley k harrisburg and Michael Rosenfeld, New York

organic shapes at the bottom. While in *Chalice*, Rindfleisch writes, Pelton constructed an art-and-science bridge that would not be crossed for decades. For years, the fallback representation of science and technology was geometrical—at its extreme, the intricate tessellations of Escher.[15] It is through these continued discoveries that new conversations on American Modernism and abstraction continue to be forged and expand our current

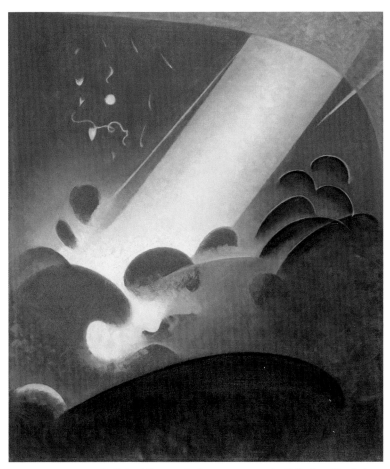

19 *Red and Blue*, c. 1938, oil on canvas, 24 × 20 in., Collection of Joe Ambrose

knowledge on the important roles women have played in the evolution and manifestation of art in the twentieth and twenty-first centuries. Agnes Pelton, like Hilma af Klint (1862–1944), stand triumphantly at the forefront of aesthetic rediscovery and feminist mindfulness.

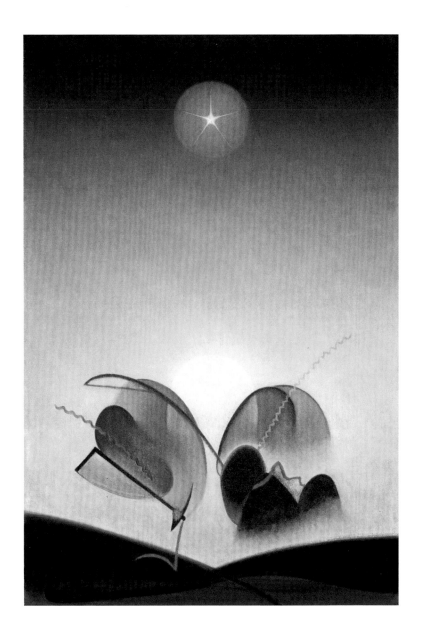

20 *Star Icon II*, c. 1939, oil on canvas
24 × 16 in., Collection of Lynda and Stewart Resnick

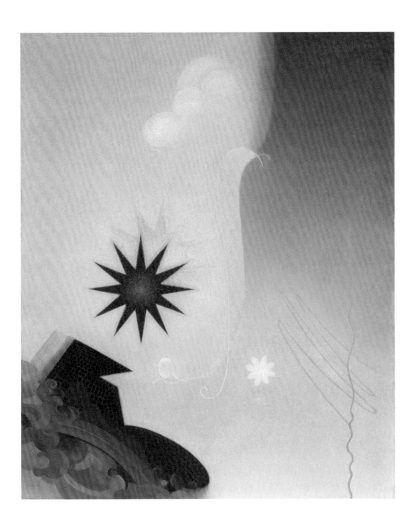

21 *Challenge*, 1940, oil on canvas, 32 × 26 in.
Fine Arts Museums of San Francisco

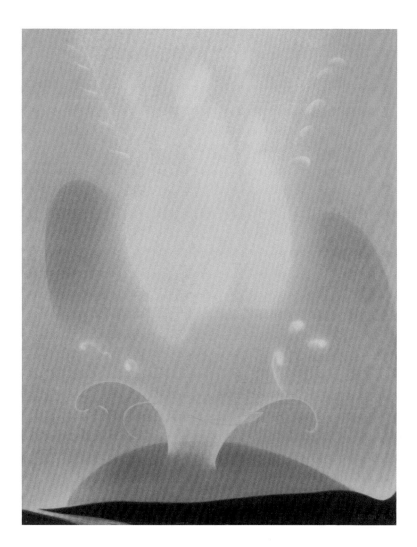

22 *The Blest*, 1941, oil on canvas, 37½ × 28¼ in., Collection of Georgia and Michael de Havenon

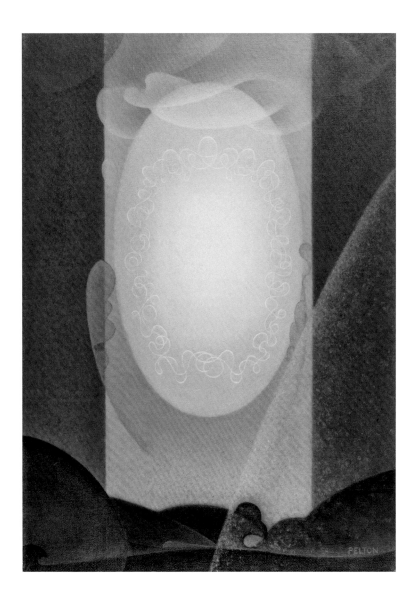

23 *Light Center*, 1947–48, oil on canvas, 36 × 25 in., Collection of Lynda and Stewart Resnick

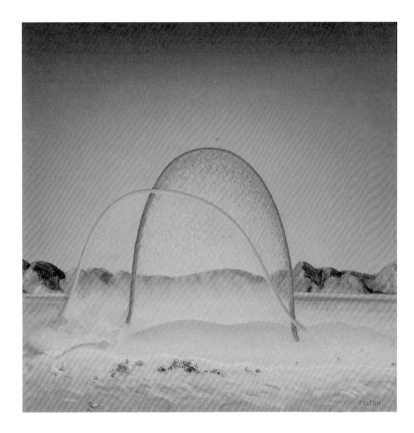

24 *Idyll*, 1952, oil on canvas, 20 × 19 in., Jeri L. Wolfson Collection

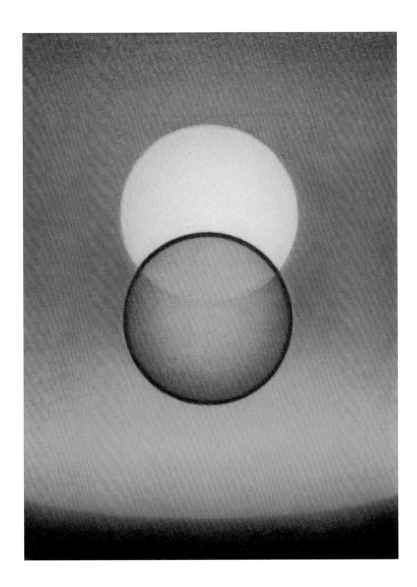

25 *Departure*, 1952, oil on canvas, 24 × 18 in., Collection of Mike Stoller and Corky Hale Stoller

GILBERT VICARIO

Gilbert Vicario is curator of modern and contemporary art at Phoenix Art Museum. Since, 2015 he has organized groundbreaking exhibitions including *Sheila Pepe: Hot Mess Formalism* (2018), *Agnes Pelton: Desert Transcendentalist* (2019), and *Stories of Abstraction: Contemporary Latin American Art in the Global Context* (2020). He is also editor of the publication *Agnes Pelton: Desert Transcendentalist.*

1 I am indebted to the early research and scholarship of Michael Zakian, Ph.D., curator of the exhibition *Agnes Pelton: Poet of Nature*, for the biographical information in this essay.
2 Alfred Stieglitz translated Kandinsky's essay "Über das Geistige in der Kunst" into English and published it in *Camera Work* in 1912.
3 Pelton was included in a group exhibition titled *Illumination: The Paintings of Georgia O'Keeffe, Agnes Pelton, Agnes Martin, and Florence Miller Pierce* (2009) that explored the connections and parallels between these four American women artists.
4 Letter from Raymond Jonson to Agnes Pelton dated June 4, 1958, Agnes Pelton Papers, 1885–1989, Archives of American Art, Smithsonian Institution.
5 James Earle and Laura Gardin Fraser Papers, Special Collections Research Center, Syracuse University Libraries.
6 Agnes Pelton Papers, 1885–1989, Archives of American Art, Smithsonian Institution.
7 Margaret Stainer, *Agnes Pelton.* Ohlone College Art Gallery, Freemont, California. October 9 – November 5, 1989.
8 *The Spiritual in Art: Abstract Painting 1890–1985* was organized by Maurice Tuchman at Los Angeles County Museum of Art in 1986.
9 Holland Cotter, "ART REVIEW; In New Jersey, Nature in Abstract and a Prison Cell," *New York Times*, July 14, 1995.
10 Phyllis Braff. "ART; Another Look at a Symbolist," *New York Times*, December 31, 1995.
11 Press release, "The Ocular Bowl," Kayne Griffin Corcoran, Los Angeles, April 2 – May 28, 2016.
12 Press release, "The Emerald Tablet," Deitch Projects Los Angeles, September 4 – October 23, 2021. The exhibition was modeled on Dorothy's quest to The Emerald City in Frank Baum's *The Wizard of Oz*, and invokes its iconography to ignite the dialogue between esotericism and popular culture. As a fervent Theosophist, a religious movement that flourished in Los Angeles at the turn of the century, Baum's Emerald City is a reference to "The Emerald Tablet of Hermes," an ancient text that formed the foundations of alchemy and all subsequent Western occult traditions.
13 Rindfleisch, Jan. "Making the Desert Flower: An Alternative Look at Rarely Seen Agnes Pelton Paintings," 2021. https://www.californiadesertart.com/making-the-desert-flower-an-alternative-look-at-rarely-seen-agnes-pelton-paintings/

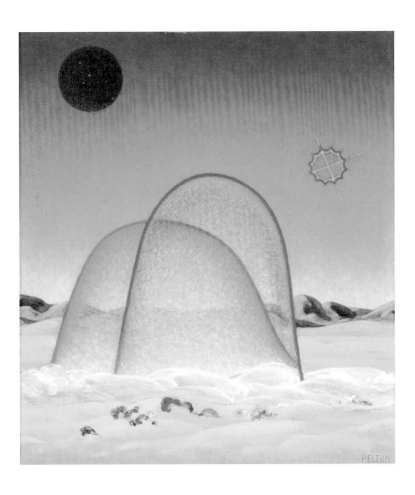

26 *Face to Face*, 1953, oil on canvas, 22½ × 20½ in.
Euphrat Museum of Art, Cupertino

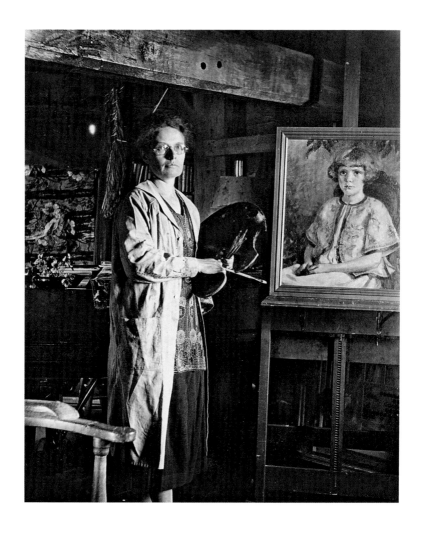

27 Agnes Pelton at work in her studio in the Old Hayground Windmill in Bridgehampton on Long Island, painting a portrait of a young girl, c. 1923

BIOGRAPHY

Agnes Pelton
1881–1961

The following biography also includes a chronology of Agnes Pelton's abstract paintings. The works painted in the respective year are always listed at the end of the corresponding entry.

1881 Agnes Lawrence Pelton is born on August 22 in Stuttgart, Germany, to American parents William Halsey Pelton (c. 1854–1891) and Florence Tilton Pelton (1856–1920).

1881–1884 As an infant, Pelton lives in Germany and the Netherlands; in 1884 she moves to Basel, Switzerland, for four years, where she is joined by her father.

1888 The family returns to the USA. Owing to poor health Pelton and her mother move to Brooklyn. Florence Pelton opens the Pelton School of Music, which she operates for the next thirty years. William Pelton returns to Europe.

1891 William Halsey Pelton dies of a morphine overdose when Pelton is nine years old.

1895 At fourteen years old, Pelton enrolls in a general art course at the Pratt Institute in Brooklyn; she studies painting with American modernist painter Arthur Wesley Dow.

1900 Pelton receives a certificate from the Pratt Institute. She assists Arthur Wesley Dow at his summer school in Ipswich, Massachusetts.

1905 Pelton visits her grandfather, Theodore Tilton, in Paris, France.

1907 Pelton studies landscape painting under William Langson Lathrop in an outdoor painting class in Old Lyme, Connecticut; she is influenced by the symbolist imagery of Arthur B. Davies.

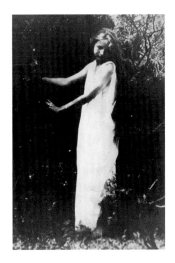

28 Agnes Pelton, n.d., photo:
H. Brandseph, Stuttgart (Germany)

29 Agnes Pelton, n.d.

30 Agnes Pelton and her mother
Florence Tilton Pelton, c. 1910

31 Agnes Pelton, n.d.
Photo: Alice Boughton

1910 At twenty-nine years old, Pelton travels to Italy and studies life drawing at the British Academy in Rome for one year.

1911 Pelton studies painting with Hamilton Easter Field at his Summer School of Graphic Arts in Ogunquit, Maine. She begins the "Imaginative Paintings," a series of symbolist figure compositions, which she continues until 1917, and has her first solo exhibition at Field's studio in August. She also begins her journal, which for the next fifty years records personal reflections, compositional sketches, and drawings.

1912 Alice Brisbane Thursby, a New York collector and chief patron of Pelton's early work, holds an exhibition of Pelton's paintings at her apartment.

1913 At the invitation of Walt Kuhn, Pelton exhibits two Imaginative Paintings, *Vine Wood* and *Stone Age*, in the 1913 Armory Show, also known as the International Exhibition of Modern Art. She meets Mabel Dodge Sterne at Alice Thursby's home, and produces paintings to accompany the Pulitzer prize winner Zona Gale's children's book, *When I was a Little Girl*.

1914 Pelton is elected a member of the Association of Women Painters and Sculptors in New York, and participates in their group exhibitions throughout the 1920s. She rents her first studio in Manhattan at 19 East 59th Street.

1915 Pelton participates in the *Exhibition of Painting and Sculpture by Women Artists for the Benefit of the Woman Suffrage Campaign* at Macbeth Gallery.

1917 Pelton joins the Society of Independent Artists. She begins exploring the intersections of art and music, and develops a lifelong interest in Madame Blavatsky's Theosophy. She creates *Room Decoration in Purple and Gray*, a mural commissioned for the mantel of Arthur Brisbane's apartment in Washington, DC. She exhibits at Gertrude Vanderbilt's Whitney Studio in New York and participates with twelve paintings in a group show titled *Imaginative Paintings by Thirty Young Artists of New York City* at the Knoedler Galleries, New York.

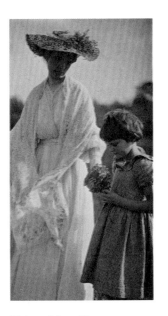

32 Agnes Pelton, n.d., photo: Alice Boughton

33 Agnes Pelton with young
cousin at Agnes' "Wild Farm"
Photo: Alice Boughton

34 Agnes Pelton in her studio in the Jefferson Market Building, 10th street and Sixth Avenue, c. 1916

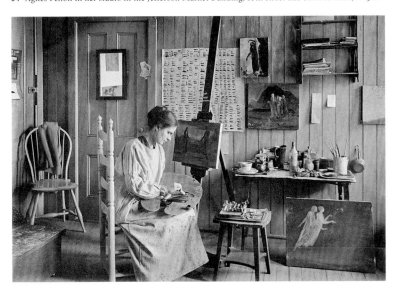

1919 At the invitation of Mabel Dodge Sterne, Pelton travels to Taos, New Mexico, with Alice Thursby. It is her first introduction to the American desert; she produces portraits of Native Americans and paintings of the New Mexico landscape. A solo exhibition of the Taos works is held at the New Mexico Museum, Santa Fe.

1920 Florence Tilton Pelton dies.

1921 Pelton rents the historic Hayground Windmill in Bridgehampton on Long Island, where she lives for the next ten years. She devotes herself to portrait painting and begins to study astrology.

1923 Pelton travels to Honolulu, Hawaii, for five months; between portrait sittings, she makes several studies of exotic native flowers. A retrospective of more than eighty paintings takes place at the Community House, Bridgehampton, Long Island.

1925 Pelton produces her first abstract painting, *The Ray Serene*, after the spiritual abstractions of Wassily Kandinsky.
 – *The Ray Serene*

1926 Pelton creates her first original abstractions, *The Fountains* and *Being*. She travels for five months to Syria, Beirut, Athens, Naples, and Constantinople.
 – *The Fountains* – *Being* – *Meadowlark's Song, Winter*

1928 Pelton rents a house for eight months and spends the winter in South Pasadena, California; she associates with "The Glass Hive," a group of writers centered around novelist William Levington Comfort.
 – *Ecstasy*

1929 Pelton returns to Long Island. Her first solo exhibition of abstract paintings is held at Montross Gallery, New York.
 – *The Guide* – *Incarnation* – *Star Gazer* – *Divinity Lotus*
 – *Radiance*

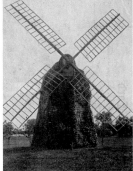

35 Agnes Pelton, n.d.

36 Old Hayground Windmill
in Bridgehampton on Long
Island, studio of Agnes Pelton,
c. 1921

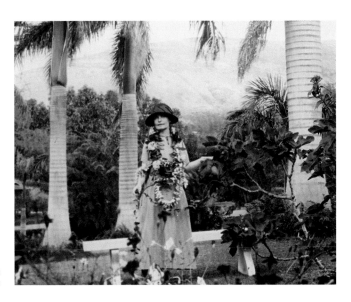

37 Agnes Pelton in
Hawaii, 1924–1925

1930 Pelton develops a strong interest in Agni Yoga, a branch of Theosophy; she also meets astrologist and composer Dane Rudhyar. *Being* and *The Fountains* are included in the 125th annual exhibition at the Pennsylvania Academy of Fine Arts in Philadelphia.

– *Illumination* – *The Voice* – *Fire Sounds*
– *Lotus for Lida (Egyptian Dawn)* – *White Fire*

1931 A solo exhibition of twenty-one abstract paintings is held at the Ardent Galleries, New York.

– *Sea Change* – *Voyaging* – *Ahmi in Egypt* – *Wells of Jade*
– *The Ray* – *Translation*

1932 The Hayground Windmill is sold by its owner and, at fifty years old, Pelton moves to Cathedral City, California, a small community six miles from Palm Springs. She exhibits twelve abstractions at the Delphic Studios, New York, and nine paintings at Bettye K. Cree's Desert Art Galleries, Palm Springs. She creates *Messengers*, her first desert abstraction.

– *Messengers* – *Sand Storm* – *Mount of Flame* – *Heart Music*

1933 Pelton exhibits fourteen abstract paintings next to works of Raymond Jonson and Cady Wells at the Museum of New Mexico, Santa Fe.

– *Winter* – *Winged Peace* – *The Primal Wing* – *Intimation*
– *Mother of Silence*

1934 Pelton exhibits twenty-five abstract paintings at the San Diego Fine Arts Gallery (now the San Diego Museum of Art). She writes poems as introductions to her abstractions, and paints *Orbits* and *The Being: A Transcendental Vision*.

– *Even Song* – *Orbits* – *The Being: A Transcendental Vision*

1935 Pelton meets Raymond Jonson in person after years of correspondence. She paints *Day*.

– *Day* – *Barna Dilae* – *Beatitude*

1936 Pelton spends the month of June painting smoke trees outdoors. She exhibits abstractions at the Laguna Beach Art Association (now the Laguna Art Museum), and exhibits landscapes and abstractions at the Desert Inn Gallery, Palm Springs (also in 1938, 1940, and 1943).

 – *Memory,* 1937 – *Alchemy,* 1937–39

1938 Mabel Dodge Luhan and Tony Luhan visit Pelton in Cathedral City. She becomes founding member and elected honorary president of the Transcendental Painting Group.

 – *Red and Blue* – *Resurgence* – *Fires in Space*

1939 Pelton exhibits *Orbits* with the Transcendental Painting Group at the Golden Gate International Exposition in San Francisco. She spends the summer on Mount San Jacinto, Idyllwild, California. Pelton paints *Star Icon II.*

 – *Star Icon II*

1940 Pelton exhibits in the Transcendental Painting Group exhibition at the Solomon R. Guggenheim Museum, New York.

 – *Nurture* – *Return* – *Challenge*

1941 Pelton buys a small cabin on Thomas Mountain, south of Mount San Jacinto.

 – *Future,* 1941 – *The Blest 7,* 1941 – *Spring Moon,* 1942

1943 Pelton exhibits abstractions at the San Francisco Museum of Modern Art. She travels to Santa Barbara, Sacramento, and Claremont in California, and Salt Lake City, Utah, with the Western Association of Art Museum Directors. She also exhibits abstractions at the Santa Barbara Museum of Art.

 – *Birthday* – *Prelude* – *Awakening (Memory of Father)*

1944 Pelton shows great interest in the writings of Krishnamurti and reads his works into the 1950s. She temporarily suspends work on abstract paintings and concentrates on desert landscapes.

1945 The Transcendental Painting Group disbands.
– *Passion Flower*

1946 Pelton resumes painting abstractions.
– *Ascent (aka Liberation)*

1947 Small exhibition of eight abstractions at the Laguna Beach Art Association.
– *Light Center*, 1947–48

1950 Pelton participates in the founding of the Desert Art Center of Cathedral City.
– *Interval* – *Yesterday, Today and Tomorrow*, early 1950s

1951 Pelton exhibits fourteen paintings at the University of Redlands, California.
– *Focus* – *Idyll*, 1952 – *Departure*, 1952

1955 Pelton exhibits paintings at the Palm Desert Art Gallery, California.
– *Lost Music II*, late 1950s

1960 Pelton sells her house and the buyer agrees to build her a smaller home on a nearby lot.
– *Light Center*, 1960–61

1961 Pelton dies on March 13, five months before her eightieth birthday. Her ashes are buried on Mount San Jacinto.

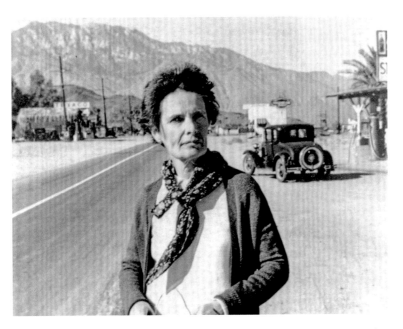

38 Agnes Pelton in Cathedral City, in the background likely Mount San Jacinto, 1930s/40s

39 Agnes Pelton, 1957

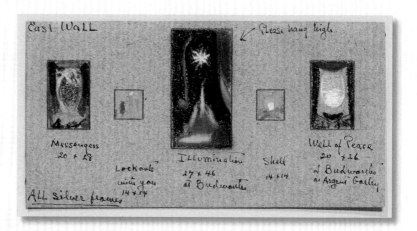

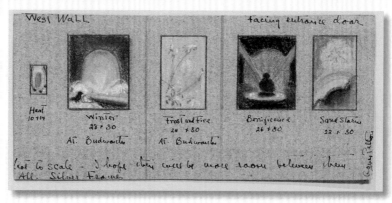

Agnes Pelton's installation instructions for an exhibition organized by the Transcendental Painting Group in New Mexico, which she did not attend. Sketched artworks: *Messengers* (13), *Lock Owls, Illumination, Shell, The Well of Peace, Heat, Winter* (14), *Frost and Fire, Beneficence, Sand Storm* (12).

ARCHIVE

Poems

There are over 25 poems documented in Agnes Pelton's archives that refer to her series of abstract paintings begun in the 1920s. To better understand their overall significance it is important to understand her artistic development as a young painter along with the philosophical influences that helped shape her practice. Research published by Dr. Michael Zakian in his 1995 exhibition publication Agnes Pelton: Poet of Nature *sheds light on the early influence of Arcadian subject matter*[1] *on Pelton's compositions while invoking references to Ralph Waldo Emerson's New England Transcendentalism. It is thought that Pelton was inspired by this nineteenth-century philosophical movement, articulated in writing and poetry, which aspired towards an idealistic system of thought based on the supremacy of insight over logic. This emphasis on the "inner realm" ultimately informed her style of painting. While Pelton's focus on the inner realm of abstraction was present in her work by the 1910s, it was not until 1925–6 that it began to dominate her practice.*

It is believed that Being (3) *was Pelton's first abstraction accompanied by an original poem. Because her abstractions tackled difficult concepts around invisibility and vibration along with some that could be traced back to the philosophy of Rudolph Steiner, her poems offered possibilities of interpretation and a pathway into her mind.* Fountains (1) *continued to tackle difficult concepts brought forth on canvas. As the title suggests, it was focused on the articulation of water as a metaphor for circulation, spirituality, and the creative impulse. This was visually articulated in an abstract composition of shimmering, circular veils of yellows and ochers offset by delicate hues of pale indigo. The fluidity and formlessness of water nonetheless grounded her abstractions in the visible world and would later become more pronounced in subsequent works.* Chalice (10), *on this point, demonstrates how Pelton's pure abstractions of the 1920s became grounded in a symmetrical, theatrical landscape a decade later. Allusions to blood-red arteries and penetration become articulated in a graphic interplay between faith, ritual, and landscape. The accompanying poem to* Chalice *is comprised of two stanzas and offers a very clean, descriptive style that focuses on the compositional elements of the painting, beginning at the top, moving towards the bottom, and then back to the top again.*

1 Zakian, Michael. "Background & Brooklyn," in *Agnes Pelton: Poet of Nature*. Palm Springs Desert Museum 1995, p. 26.

The Fountains

Two balanced forces
Rising from a pool
To play in harmony
Like water – fountain music

The golden disc of day irradiating
Fires and lights their movement

Opposite, yet side by side
Felicity mounts upward
To fall, and rise again

And from this confluence
Descends a sphere
Lucent as the dawn
Of a new day.

Chalice

A warm sky pales to clear light green
Above a garnet mound –
Its center cut
By waving colored lines
Nine little flames of purest blue
Play lightly on each side.

Rising from out the cleft
A golden shape, expands
Above which poised, there rests
A chalice, opal white.
Red lines of fire etch its sides
Confined within its being –
Glowing, burning, rising
And guarded by the mystery above.

SOURCES

The originals were graciously provided by the museums and collections named in the captions or by the following archives (numbers are page numbers):

Archives of American Art, Smithsonian Institution: 46, 51 below, 53 middle

Bequest of Raymond Jonson, Raymond Jonson Collection, University of New Mexico Art Museum, Albuquerque: 19, 27

Collection of Carolyn Tilton Cunningham. Courtesy of Nyna Dolby: 49, 51 above left and right, 53 above and below, 57 below

Collection of Georgia and Michael de Havenon: 10, 40

Collection of halley k harrisburg and Michael Rosenfeld, New York; Courtesy of Michael Rosenfeld Gallery LLC, New York: 36

Collection of Joe Ambrose: 37

Collection of Laurie M. Tisch: 14

Collection of Lynda and Stewart Resnick: 8, 38, 41

Collection of Maurine St. Gaudens: 13

Collection of Mike Stoller and Corky Hale Stoller: 43

Crocker Art Museum Purchase; Paul LeBaron Thiebaud, George and Bea Gibson Fund, Denise and Donald C. Timmons, Melza and Ted Barr, Sandra Jones, Linda M. Lawrence, Nancy Lawrence and Gordon Klein, Nancy S. and Dennis N. Marks, William L. Snider and Brian Cameron, Stephenson Foundation, Alan Templeton, A.J. and Susana Mollinet Watson, and other donors: 31

Crystal Bridges Museum of American Art, Bentonville, Arkansas: 28

Des Moines Art Center's Louise Noun Collection of Art by Women through Bequest: 15

Fairfax Dorn and Marc Glimcher: 24/25

Fine Arts Museums of San Francisco, museum purchase, Harriet and Maurice Gregg Fund for American Abstract Art, The Harriet and Maurice Gregg Collection of American Abstract Art: 39

Jeffrey Deitch: 16/17, 21, 26, 45

Jeri L. Wolfson Collection: 22, 42

Oakland Museum of California; Gift of Concours d'Antiques, the Art Guild of the Oakland Museum of California: 33

Palm Springs Historical Society: 57 above

Phoenix Art Museum, Gift of The Melody S. Robidoux Foundation: 29, 34/35

Private Collection, Jackson: 32

—

LITERATURE USED

Karen Moss, Illumination: *The Paintings of Georgia O'Keeffe, Agnes Pelton, Agnes Martin, and Florence Miller Pierce*, London: Merrell Published Limited 2009.

Margaret Stainer, *Agnes Pelton*, Fremont: Ohlone College 1989.

Michael Zakian, *Agnes Pelton: Poet of Nature*, Palm Springs: University of Washington Press 1995.

Agnes Pelton Papers, 1885–1989, Archives of American Art, Smithsonian Institution.

Agnes Pelton poems: Agnes Pelton papers, 1885–1989, Archives of American Art, Smithsonian Institution

The biography and chronology of Agnes Pelton's images was researched, compiled and written by Rachel Sadvary Zebro.

Published by
Hirmer Verlag GmbH
Bayerstraße 57–59
80335 Munich
Germany

Cover: *The Chalice* (detail), 1932, see p. 26
Double page 2/3: *Ecstasy* (detail), 1928, see p. 15
Double page 4/5: *Rose and Palm* (detail), 1931,
see p. 21

www.hirmerpublishers.com

—

COPY-EDITING
Jane Michael, Munich

–

PROJECT MANAGEMENT
Rainer Arnold, Munich

–

GRAPHIC DESIGN AND PRODUCTION
Marion Blomeyer, Rainald Schwarz, Munich

–

PRE-PRESS AND REPRO
Reproline mediateam GmbH, Munich

–

PRINTING AND BINDING
Passavia Druckservice GmbH & Co. KG, Passau

Bibliographic information published by the
Deutsche Nationalbiliothek. The Deutsche National-
bibliothek lists this publication in the Deutsche
Nationalbibliografie; detailed bibliographic data is
available on the Internet at http://dnb.d-nb.de..

ISBN 978-3-7774-3929-7

Printed in Germany